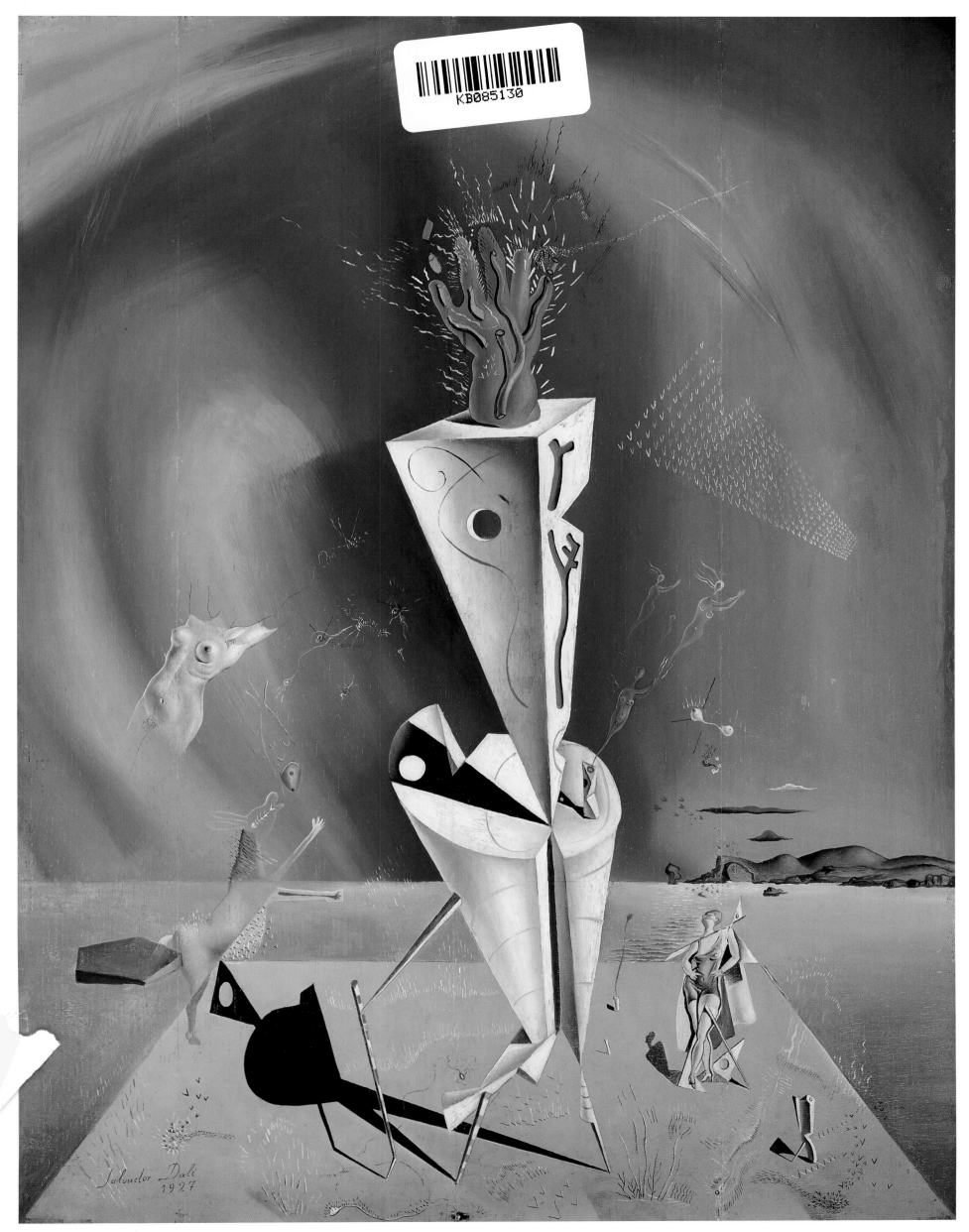

살바도르 달리 기관(器官)과 손, 1927년

Salvador Dalí
Apparatus and Hand, 1927
Apparat und Hand
Appareil et main
기관(器官)과 손
器官と手

Oil on panel, 62.2 x 47.6 cm
St. Petersburg (FL), The Salvador Dalí Museum

"Painters, do not fear perfection. You will never achieve it!"

„Maler, fürchtet nicht die Perfektion. Ihr werdet sie nie erlangen!"

« Peintres, ne craignez pas la perfection. Vous n'y parviendrez jamais ! »

"화가여, 완벽함을 두려워 마시오. 당신들은 결코 거기 도달하지 못할 테니!"

「画家の諸君、完璧さを恐れることはない。そこに到達することはないのだから!」

SALVADOR DALÍ

Salvador Dalí

살바도르 달리

마로니에북스 TASCHEN

SALVADOR DALÍ (1904–1989)

"Every morning when I awake," said the painter of *Soft Watches* (later retitled *The Persistence of Memory*), "the greatest of joys is mine: that of being Salvador Dalí ..." The native Catalonian was obsessed with both money and fame; painting and speaking were his main occupations, his favourite subject – how to discover one's genius. Not exactly loved by the Surrealists, who criticised him for extravagance and his addiction to money (it was André Breton who came up with the anagram "Avida Dollars"), Dalí's paranoiac-critical method nonetheless provided them with a first-rate instrument to liberate intelligence and imagination from the bonds of memory and dreams.

Had he been born during the Renaissance, his genius would have met with greater acceptance than was the case in our era, which saw him as a constant source of provocation; he, for his part, described the era as "degenerate". Dalí commented: "The only difference between me and a madman is the fact that I am not mad", remarking pithily that "The difference between me and the Surrealists is that I am a Surrealist." Dalí decodes the fantasies and symbols of his Surrealist visions, penetrating the depths of the irrational and subconscious, elevating hard and soft to the level of aesthetic principles. He and Gala, his wife and muse, are mythical couple, she his "existential double", his "perpetuation in immortal memory". At the age of three, Dalí had wanted to become a cook, aged five Napoleon. Thereafter, he continually aspired to something higher – to be divine Dalí forever...

„Jeden Morgen, wenn ich erwache", schrieb der Maler der *Weichen Uhren*, „mache ich die erfreuliche Feststellung: Ich bin Salvador Dalí ..." Der gebürtige Katalane war versessen auf Geld und Ruhm; Malen und Reden waren seine Hauptbeschäftigung. Dalís Lieblingsthema: Wie entdeckt man sein Genie? Von den Surrealisten, die ihm seine Übertreibungen und seine Habgier vorwarfen, nicht gerade geliebt (von André Breton stammt das Anagramm „Avida Dollars"), lieferte ihnen Dalí dennoch mit seiner Methode der „kritischen Paranoia" ein erstklassiges Instrument, aus Erinnerungen oder Träumen Intelligenz und Phantasie zu entfesseln.

Wäre er zur Zeit der Renaissance geboren, hätte sein Genie eine größere Akzeptanz gefunden als in unserem Zeitalter, das ihn als ständige Provokation sah und das er seinerseits als „degeneriert" bezeichnete. Dalí drückte es so aus: „Der einzige Unterschied zwischen einem Verrückten und mir ist der, daß ich nicht verrückt bin." Und auch der folgende Ausspruch ist zutreffend: „Der Unterschied zwischen den Surrealisten und mir ist der, daß ich Surrealist bin." Denn Dalí entschlüsselt die Phantasiegebilde und Symbole seiner surrealistischen Visionen und dringt in die Tiefen des Irrationalen und Unterbewußten vor, wo Weich und Hart zu ästhetischen Prinzipien erhoben werden. Er und Gala, seine Frau und Muse, sind ein mystisches Paar. Sie ist das „Double seiner Existenz", sein „Fortbestehen in der unsterblichen Erinnerung". Im Alter von drei Jahren wollte Dalí Koch werden; mit fünf Jahren Napoleon. Seitdem strebte er stets nach Höherem: für immer der göttliche Dalí sein...

« Chaque matin au réveil », a écrit le peintre des *Montres molles*, « j'expérimente un plaisir suprême: celui d'être Salvador Dalí ... » Catalan assoiffé d'or et de gloire, Dalí a beaucoup peint et beaucoup parlé. Son sujet favori : comment on devient un génie. Mal aimé des surréalistes qui lui reprochaient ses outrances et son amour de l'argent (c'est André Breton qui a créé l'anagramme « Avida Dollars »), Dalí leur a pourtant apporté, avec sa méthode « paranoïaque critique », un instrument de tout premier ordre : à partir d'un souvenir ou d'un rêve, déchaîner son intelligence et ses fantasmes.

Serait-il né au temps de la Renaissance que son génie aurait été plus admissible. Mais à notre époque, qu'il qualifiait de « crétinisante », il était une provocation permanente. Il a dit : « L'unique différence entre un fou et moi, c'est que moi je ne suis pas fou. » Il a dit aussi, ce qui est tout aussi vrai : « La différence entre les surréalistes et moi, c'est que moi je suis surréaliste. » Dalí décrypte, en effet, les fantasmes et les symboles de ses visions surréelles. Il plonge dans les profondeurs de l'irrationnel et du subconscient, où le mou et le dur sont érigés en principes esthétiques. Il forme avec Gala, son épouse et son égérie, un couple mythique. Elle est son « double essentiel », sa « persistance de l'immortalité de la mémoire ».

A trois ans, Dalí voulait être « cuisinière ». A cinq ans, Napoléon. Ensuite, son ambition ne cessera de grandir : être pour toujours le divin Dalí...

"매일 아침, 잠에서 깰 때 가장 큰 기쁨은 내가 살바도르 달리라는 것이다." 〈늘어진 시계〉(후에 〈기억의 지속〉으로 제목이 바뀜)를 그린 화가는 이렇게 말했다. 돈과 명예에 집착한 이 카탈루냐 출신 화가의 주된 일은 그림 그리기와 말하기였다. 그가 가장 좋아한 주제는 인간의 천재성을 발견하는 방법이었다. 초현실주의자들은 그를 좋아하지 않았다. 그들은 달리의 과장된 행동과 돈에 대한 탐욕을 비판했다(앙드레 브르통은 달리의 이름 철자를 바꾸어 "돈을 탐내는 자(Avida Dollars)"라는 말을 만들었다). 그럼에도 불구하고, 달리의 편집광적 비평방법은 기억과 꿈의 속박에서 지성과 상상력을 해방하는 최상의 도구를 초현실주의자들에게 제공했다.

르네상스기에 태어났더라면, 그의 뛰어난 재능은 더 큰 호응을 얻었을 것이다. 하지만 우리 시대에 그는 끊임없는 도발의 원천으로 간주되었다. 반면 달리는 이 시대가 "타락"했다고 말했다. 달리는 "내가 초현실주의자들과 다른 점은 나야말로 초현실주의자라는 것이다"라고 강조하면서, "나와 미친 사람 사이의 유일한 차이점은 내가 미치지 않았다는 사실이다"라고 말했다. 그는 비이성과 잠재의식의 깊숙한 곳까지 파고들며, 딱딱한 것과 부드러운 것을 미적 원리의 단계까지 끌어올린다. 그럼으로써 그는 자신의 초현실주의적 환영의 환상과 상징을 풀어서 설명한다. 달리, 그리고 그의 아내이자 뮤즈인 갈라는 신화적인 한 쌍이며, 갈라는 그의 "실존적 분신"이자 그의 "불멸의 기억의 영속"이다. 달리는 세 살 때 요리사가 되고 싶어 했고, 다섯 살에는 나폴레옹이 되고 싶어 했다. 그 후 그는 계속해서 더 높은 것을 열망했다. 그는 영원히 신과 같은 달리가 되길 원했다.

「毎朝目覚める時、私はこの上ない喜びに浸る。私はサルヴァドール・ダリなのだという喜びに・・・」《柔らかい時計（後に「記憶の固執」と改題された）》の画家はこう語った。富と名声に執着し、絵と話術に長けたこのカタロニア人は、人はいかにして天賦の才を見出すか、というテーマに惹かれていた。シュルレアリストたちから好意を持たれるどころか、むしろ浪費家で金銭欲が強いために批判されていたダリだが（「ドル亡者(Avida Dollars)」という Salvador Dali の綴りを組みかえたアナグラムを思いついたのはアンドレ・ブルトンだった）、その偏執狂的批判的方法は、シュルレアリストが記憶と夢想の結びつきから知性と想像力を解放するのに何よりも役立った。

もしダリがルネサンスの時代に生まれていたなら、その才能はもっと広く受け入れられていただろう。ダリが生きた時代は、彼を常に挑発者と見なし、ダリのほうもそんな現代を「退廃的」と批判した。「私と狂人の唯一違うところは、私が狂人ではないということだ。そして私とシュルレアリストとの違いは、私がシュルレアリストである点である」とダリはあっさり言ってのける。ダリは自分のシュルレアリスト的ヴィジョンの空想とシンボルを読み解き、不合理さと潜在意識の奥深くまで洞察し、硬さと柔らかさを美の本質のレベルまで引き上げた。ダリとその妻であり彼の霊感の源泉でもあったガラは、神秘的な夫婦だった。ガラはダリにとって「まさに2役」をこなし、「不死の記憶を永続させる」存在であった。3歳でコックになりたいと思い、5歳の時にはナポレオンになりたいと思ったダリは、その後さらなる大志を抱き続け、――永遠に神聖なダリ――となることを切望した。

포트폴리오
살바도르 달리

발행일: 2006년 3월 1일
펴낸이: 이상만
펴낸곳: 마로니에북스
등록: 2003년 4월 14일 제2003-71호
주소: (110-809) 서울시 종로구 동숭동 1-81
전화: 02-741-9191(대) / 편집부 02-744-9191 / 팩스 02-762-4577
홈페이지 www.maroniebooks.com

ISBN 89-91449-44-1 (SET 89-91449-69-7)

Korean Translation © 2006 Maroniebooks, Seoul

Salvador Dalí: Portfolio
© 2006 TASCHEN GmbH
Hohenzollernring 53, D–50672 Köln
www.taschen.com

Original edition: © 2001 TASCHEN GmbH
All images provided by te Neues Verlag, Kempen
© Salvador Dalí. Foundation Gala – Salvador Dalí/VG Bild-Kunst, Bonn 2004
Cover: Leda atomica, 1949
Text: Gilles Néret, Paris

Printed in China

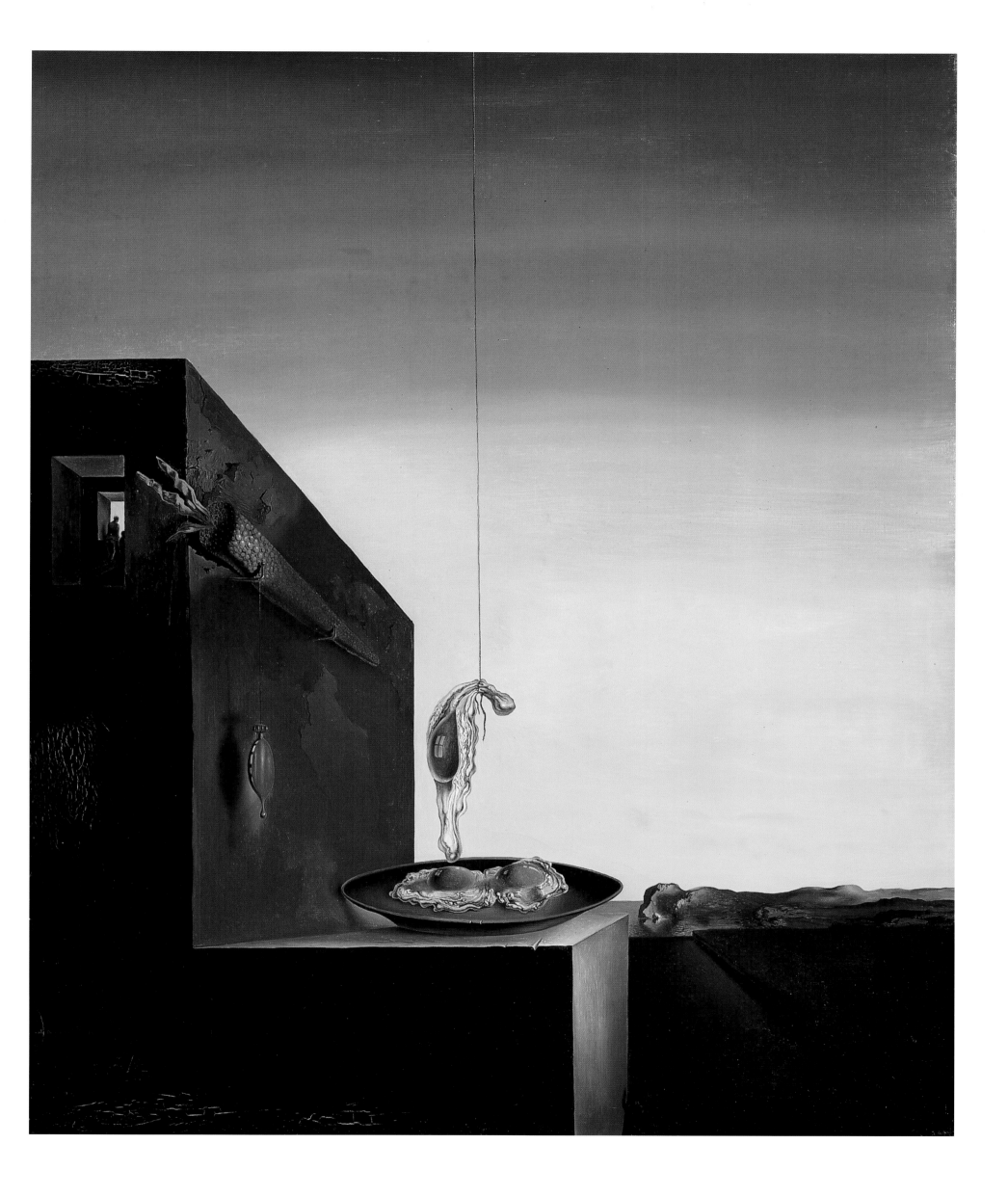

살바도르 달리 접시 없이 접시 위에 놓인 달걀 프라이, 1932년

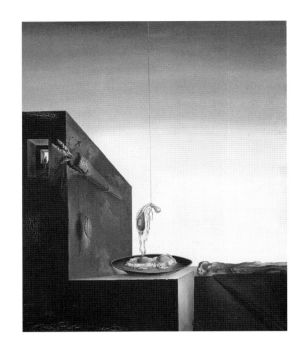

Salvador Dalí
Fried Eggs on the Plate without the Plate, 1932
Spiegeleier auf dem Teller ohne den Teller
Œufs sur le plat sans le plat
접시 없이 접시 위에 놓인 달걀 프라이
皿のない皿の上の目玉焼き

Oil on canvas, 60 x 42 cm
St. Petersburg (FL), The Salvador Dalí Museum

The "soft" egg, a favourite Dalínian motif, which he links to
pre-natal images and the intra-uterine universe.

Das „weiche" Ei, ein bevorzugtes Thema Dalís, verbindet sich mit
pränatalen Bildern und mit dem intrauterinen Universum.

L'œuf « mou », thème cher à Dalí, qui l'assimile aux images prénatales
et à l'univers intra-utérin.

달리는 자신이 즐겨 그리는 주제인 '흐물거리는' 달걀을
태아의 이미지, 그리고 자궁 속의 우주와 연결했다.

この「柔らかい」卵というお気に入りのモティーフを、
ダリは胎児期のイメージや子宮内部の世界と結び付けている。

© 2006 TASCHEN GmbH
Hohenzollernring 53, D–50672 Köln
www.taschen.com
Photo: The Salvador Dalí Museum, St. Petersburg (FL)

Korean Translation © 2006 Maroniebooks, Seoul
www.maroniebooks.com

살바도르 달리, 정물—빠르게 움직이는, 1956년

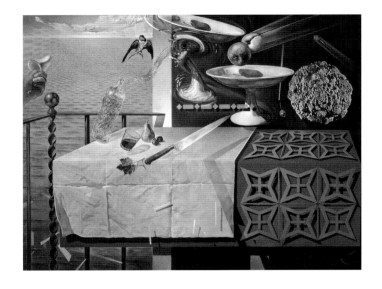

Salvador Dalí
Still Life – Fast Moving, 1956
Lebendes Stilleben
Nature morte vivante
정물──빠르게 움직이는
静物画(速い動き)

Oil on canvas, 125 x 160 cm
St. Petersburg (FL), The Salvador Dalí Museum

"My ideas were ingenious and abundant. I decided to turn my attention to the pictorial
solution of quantum theory, and invented quantum realism in order to master gravity."

„In einem genialen Überschäumen von Ideen beschloß ich, mich an die bildnerische Lösung
der Quantentheorie zu begeben, und ich erfand den ‚Quantenrealismus', um der Schwerkraft
Herr zu werden."

« Dans un bouillonnement génial d'idées, je décidai m'attaquer à la résolution plastique
de la théorie du quantum d'énergie et j'inventai le ‹réalisme quantifié› pour me rendre
maître de la gravitation. »

"내 아이디어는 독창적이고 풍부했다. 나는 양자 이론을 회화적으로 풀이하기로 결심하고,
중력을 지배하기 위해 양자 사실주의를 창안했다."

「私のアイデアは、豊富で独創的だった。量子理論を絵画的に解決することにしたり、
重力を支配するために量子化されたレアリスムを発明した」

SALVADOR DALÍ

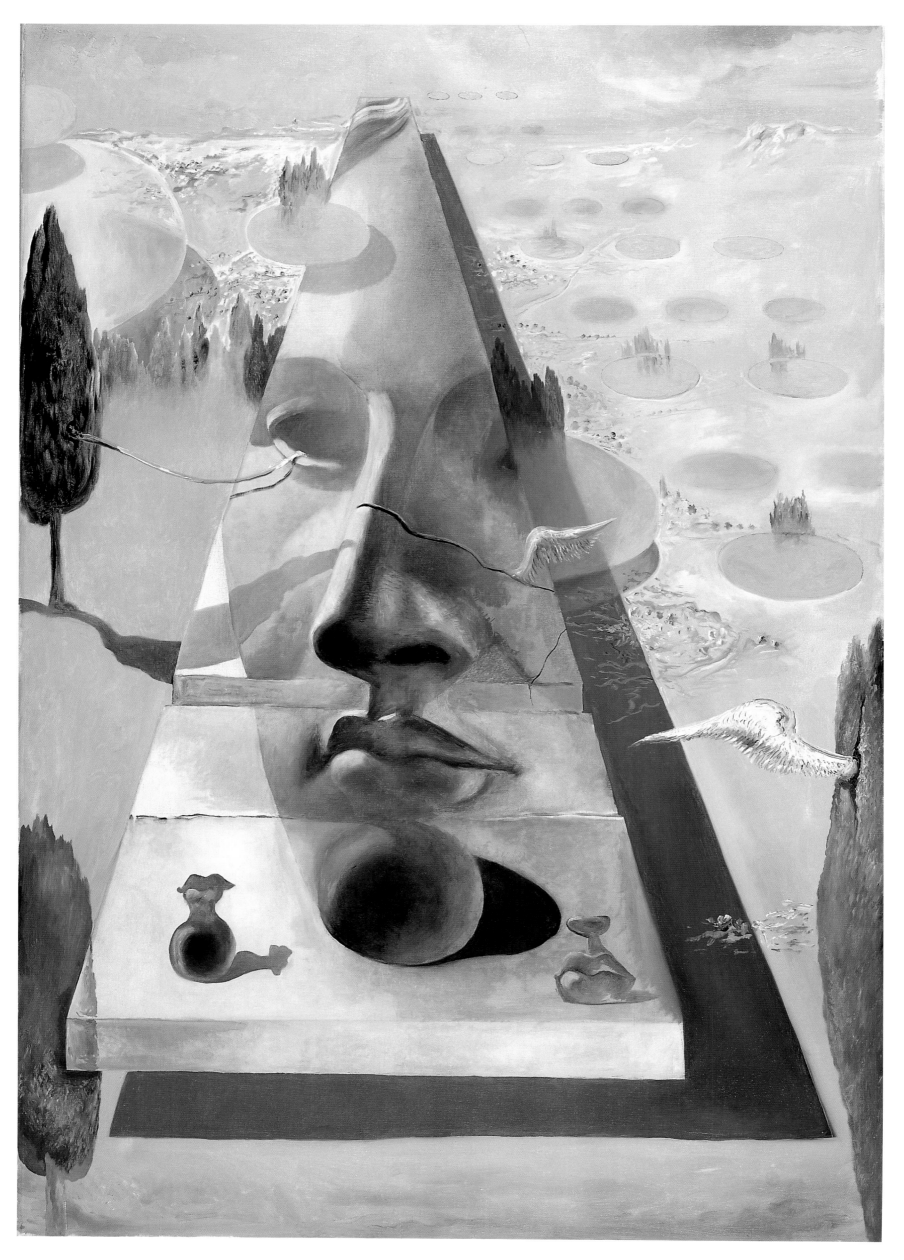

살바도르 달리 풍경 속에 나타난 크니도스의 아프로디테의 얼굴, 1981년

Salvador Dalí
Apparition of the Visage of Aphrodite of Cnidos in a Landscape, 1981
Erscheinung des Gesichts der Aphrodite von Knidos in einer Landschaft
Apparition du visage de l'Aphrodite de Cnide dans un paysage
풍경 속에 나타난 크니도스의 아프로디테의 얼굴
風景の中に出現したクニドスのアフロディテの顔

Oil on canvas, 140 x 96 cm
Figueras, Fundación Gala-Salvador Dalí

Dalí, "a true athlete of the psyche" (as Dr. Pierre Roumeguère once called him),
took an early interest in abnormalities of visual perception, intending
to subject them to his own expressive intentions.

Als „echter psychischer Athlet", wie er einmal von Doktor Pierre Roumeguère
bezeichnet wird, hat sich Dalí sehr früh mit „visuellen Abweichungen"
auseinandergesetzt, mit dem Ziel, sie seinem Ausdruckswillen zu unterwerfen.

« Veritable athlète psychique », selon le docteur Pierre Roumeguère,
Dalí s'est empoigné très tôt avec les « aberrations visuelles » afin de les soumettre
à son pouvoir.

피에르 루므게르 박사의 말대로라면 "진정한 정신의 운동선수"였던 달리는
일찌감치 시각적 지각의 변칙에 관심을 보여, 그것을
자신만의 표현 의도에 종속시키려 했다.

「本物の精神的なスポーツマン」(とピエール・ルミーグレー博士はかつて
ダリをこう呼んだことがある)であるダリは、初期の頃から視感異常に興味を示し、
自分の表現方法に用いようとした。

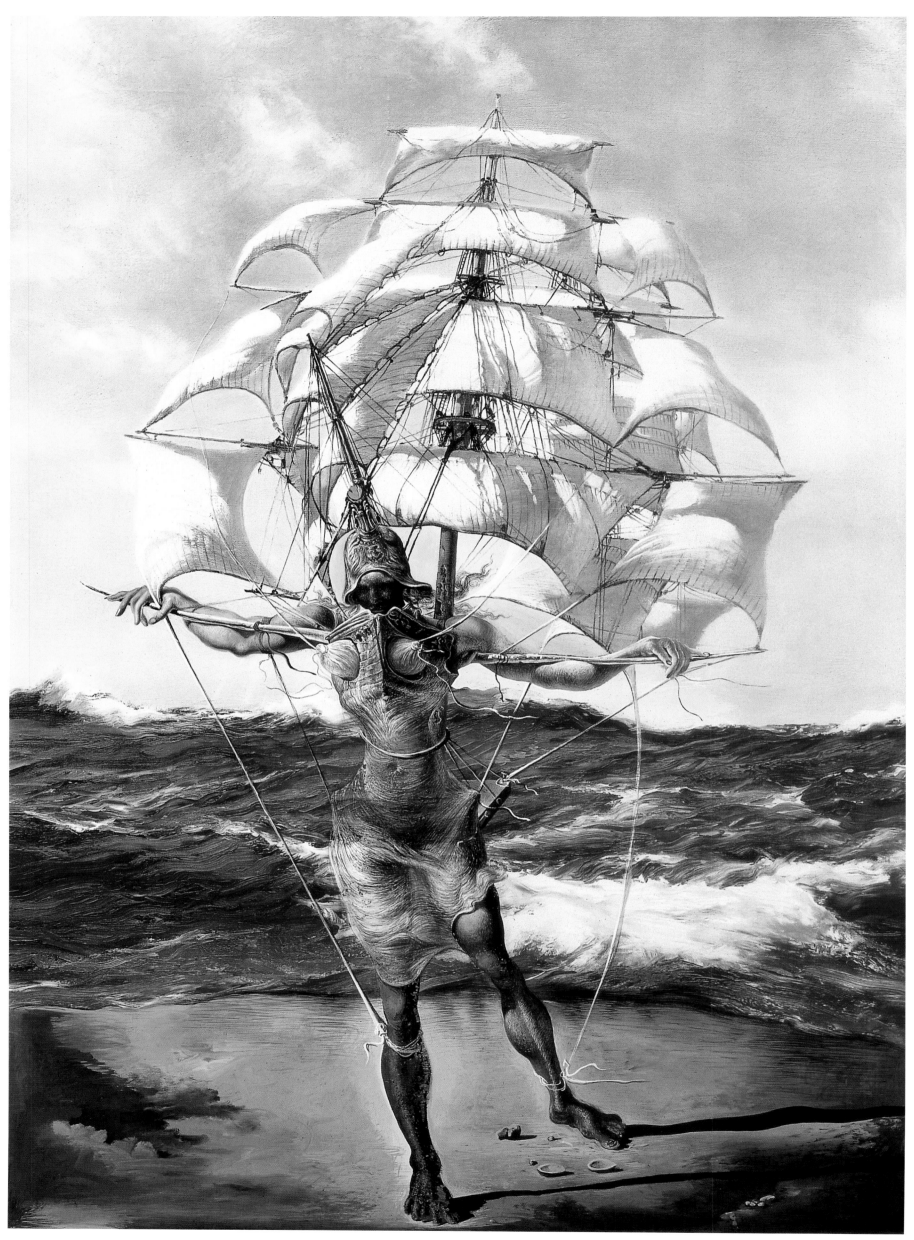

살바도르 달리 '미친 트리스탄'을 위한 의상—배, 1942/43년

Salvador Dalí
Costume for "Tristan Insane" – The Ship, 1942/43
Kostüm für „Der wahnsinnige Tristan" – Das Schiff
Costume pour « Tristan Fou » – Le navire
'미친 트리스탄'을 위한 의상―배
『狂えるトリスタン』衣装 − 船

Watercolour, 63 x 46 cm
St. Petersburg (FL), The Salvador Dalí Museum

"I believe in magic, which ultimately consists quite simply in the
ability to render imagination in the concrete terms of reality."

„Ich glaube an die Magie, die letzten Endes ganz einfach in dem
Vermögen besteht, die Phantasie in der Realität zu konkretisieren."

« Je crois en la magie qui, en dernière analyse, est tout simplement
le pouvoir de matérialiser l'imagination en réalité. »

"나는 마법을 믿는다.
마법이란 결국 상상을 현실로 구체화하는 능력일 뿐이다."

「マジックは、結局、現実に実在する具象化したものを想像の世界に変えてしまうと私は思う」

SALVADOR DALÍ

Salvador Dalí
The Temptation of Saint Anthony, 1946
Die Versuchung des heiligen Antonius
La tentation de Saint Antoine
성 안토니우스의 유혹
聖アントワーヌの誘惑

Oil on canvas, 89.7 x 119.5 cm
Brussels, Musées Royaux des Beaux-Arts de Belgique

Dalí is about to leave the earth in order to reach the heavenly spheres. The dimension mediating between heaven and earth is embodied in the elephants with their spindly legs. They introduce the theme of levitation that was to be fully developed soon after in his "mystical-corpuscular" paintings.

Dalí schickt sich an, die Erde zu verlassen, um himmlische Sphären zu erreichen. Die zwischen Himmel und Erde vermittelnde Dimension wird durch die Elefanten „mit spindeldürren Beinen" verbildlicht. Sie leiten das Thema der Levitation ein, das sich bald in den Gemälden der „korpuskulären Mystik" entfalten sollte.

Quand Dalí s'efforce de quitter la terre pour atteindre les sphères célestes. Cette dimension inter-médiaire entre Ciel et Terre est figurée par ces éléphants « aux pattes arachnéennes ». Ils amorcent le thème de la lévitation qui s'épanouira bientôt dans ses peintures « mystiques corpusculaires ».

달리는 천상의 영역에 닿기 위해 지상을 떠나려고 한다.
천상과 지상을 중재하는 차원은 가늘고 긴 다리를 가진 코끼리로 구현된다. 이 코끼리들은
'신비주의적 미립자' 회화 이후 완숙한 발전을 보여준 공중부양의 주제를 나타낸다.

ダリは天国のような天空をめざして地上を旅立とうとしている。
天国と地球の間を取り次ぐ次元は、ひょろ長い足をした象で具現されている。
「神秘的微粒子」の絵後まもなく完成することになる空中浮揚のテーマを披露している。

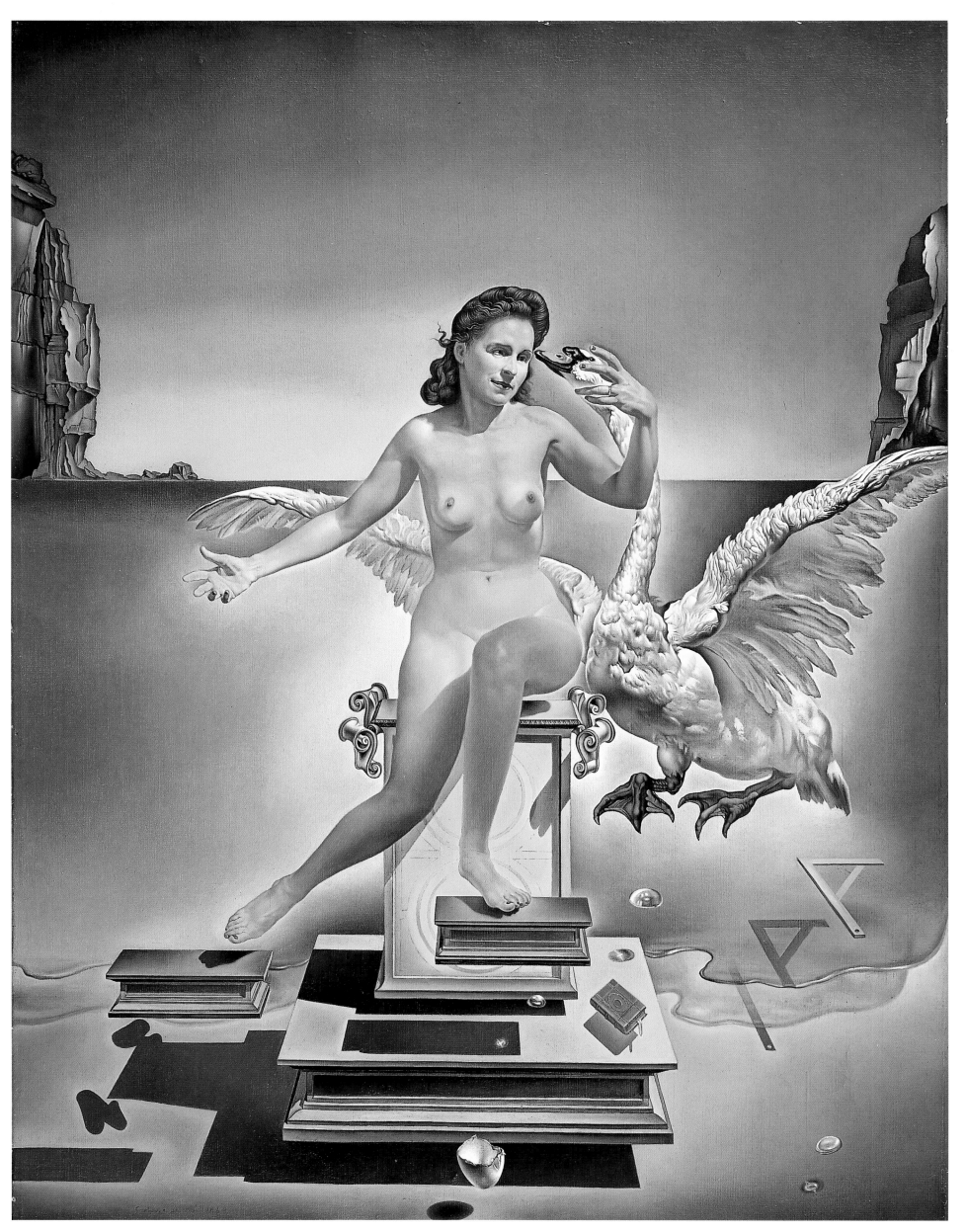

살바도르 달리 **원자의 레다**, 1949년

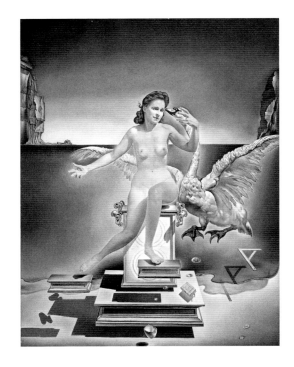

Salvador Dalí
Leda atomica, 1949
원자의 레다
レダ・アトミカ

Oil on canvas, 61.1 x 45.3 cm
Figueras, Fundación Gala-Salvador Dalí

Dalí continues the earthly saga of the Salvador-Gala couple thirsting after the absolute:
"*Leda Atomica* is the key painting of our lives. Everything in it is suspended in space without
anything touching anything else. Death has lifted itself above the earth."

Dalí spinnt weiter an der irdischen Saga des Paares Salvador-Gala, das nach dem Absoluten
dürstet: „Die *Leda Atomica* ist das Schlüsselbild unseres Lebens. Alles ist in den Raum gehängt,
ohne daß irgend etwas irgend etwas anderes berührte. Der Tod selbst hebt sich von der Erde
ab in die Höhe."

Dalí poursuit la saga terrestre du couple Salvador-Gala assoiffé d'absolu : « La *Leda atomica*
est le tableau-clé de notre vie. Tout y est suspendu dans l'espace sans que rien ne touche à rien.
La mort elle-même s'élève à distance de la terre ».

달리는 절대적인 것을 추구하는 살바도르–갈라 부부의 세속적인 모험담을 계속 다루었다.
〈원자의 레다〉는 우리 삶의 비밀을 보여주는 열쇠 같은 작품이다. 그림의 모든 모티프는
서로에게 닿지 않은 채 공중에 떠 있다. 죽음조차도 지상에서 떨어져 있다."

絶対的なものを渇望するダリとガラ夫妻の純朴な冒険をダリは描き続ける。
「《レダ・アトミカ》は私たちの人生において重要な作品だ。この絵の中のすべてのものが
何にも全く触れずに宙に浮いている。海も地上から離れて浮かんでいる」

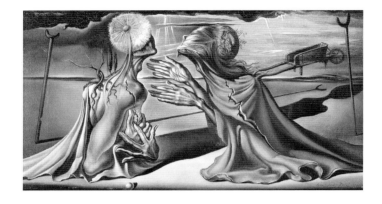

Salvador Dalí
Design for the set of the ballet "Tristan and Isolde", 1944
Vorlage für das Bühnenbild des Balletts „Tristan und Isolde"
Maquette pour le rideau de scène du ballet « Tristan et Isolde »
발레 '트리스탄과 이졸데'의 무대 막
バレエ「トリスタンとイゾルデ」の舞台の下絵

Oil on canvas, 26.7 x 48.3 cm
Figueras, Fundación Gala-Salvador Dalí

During his visit to New York, Dalí took up a serious study of Wagner's opera "Tristan und Isolde".
Many of his important paintings, stage designs and costumes derive from his fascination with the
myth of love until death.

Während seines Aufenthalts in New York setzt sich Dalí intensiv mit Richard Wagners
Oper „Tristan und Isolde" auseinander. Fasziniert vom Mythos der Liebe bis zum Tod,
entwirft er zahlreiche bedeutsame Gemälde, Bühnenbilder und Kostüme.

Durant son séjour à New York, Dalí fait une étude approfondie de l'opéra de Wagner « Tristan
et Isolde ». Fasciné par le mythe de l'amour jusque dans la mort, il peindra sur ce thème de
nombreux tableaux et réalisera des décors et des costumes pour la scène.

뉴욕을 방문했을 때, 달리는 바그너의 오페라 '트리스탄과 이졸데'에 대해 진지하게 공부했다.
그는 죽음에 이르는 이 사랑의 신화에 매혹되어 많은 회화와 무대 장식, 의상을 제작했다.

ダリはニューヨークを訪問中、ヴァーグナーのオペラ「トリスタンとイゾルデ」を研究した。
生涯の間、ダリの重要な絵画、舞台装置、衣装などはその愛の神話をもとにしていた。

© 2006 TASCHEN GmbH
Hohenzollernring 53, D–50672 Köln
www.taschen.com
Photo: Fundación Gala-Salvador Dalí, Figueras

Korean Translation © 2006 Maroniebooks, Seoul
www.maroniebooks.com

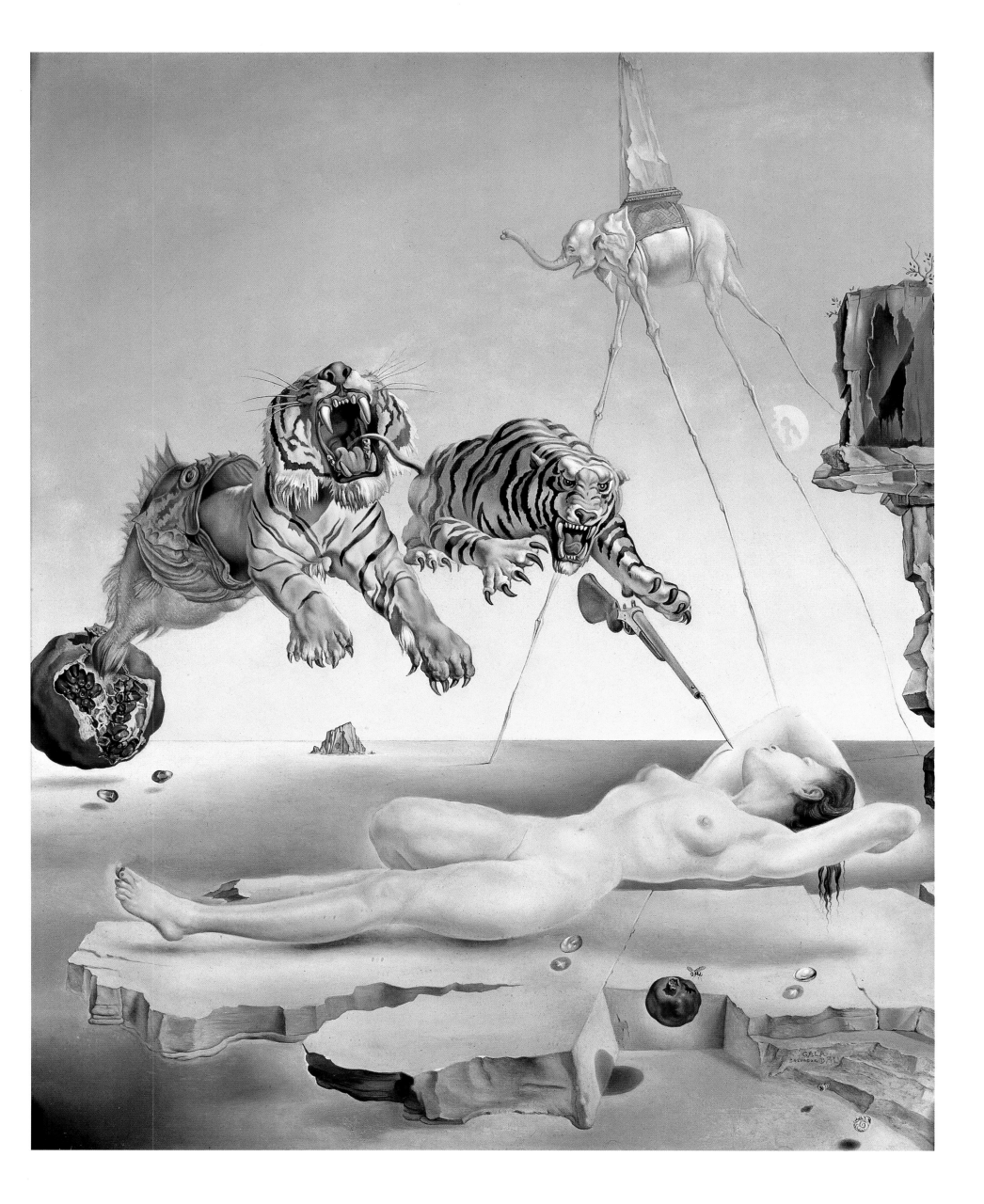

살바도르 달리 **석류 주위를 나는 벌에 의한 꿈, 깨어나기 1초 전**, 1944년

Salvador Dalí
Dream Caused by the Flight of a Bee around a Pomegranate a Second before Awakening, 1944
Traum, verursacht durch den Flug einer Biene um einen Granatapfel, eine Sekunde vor dem Aufwachen
Rêve causé par le vol d'une abeille autour d'une pomme grenade une seconde avant l'éveil
석류 주위를 나는 벌에 의한 꿈, 깨어나기 1초 전
ザクロの実の周囲を1匹のミツバチが飛び回ったために見た夢

Oil on canvas, 51 x 40.5 cm
Madrid, Museo Thyssen-Bornemisza

The picture's central focus is Gala asleep, floating over a surreal landscape.
According to Dalí, the buzzing bee communicates a danger (its sting) to the unconscious mind
of the resting woman, thereby triggering a dream. In assembling the dream's content,
Dalí quotes classical images from Freud's dream symbolism.

Bildmittelpunkt ist die schlafende Gala, die über einer surrealen Traumlandschaft schwebt.
Die Biene kündigt, laut Dalí, dem Tiefenbewußtsein der ruhenden Frau eine Gefahr (Stich) an
und löst einen Traum aus. Für dessen Inhalte greift er auf Freuds Traumsymbole zurück.

Au centre de la toile, Gala endormie plane au dessus d'un paysage de rêve suréel. Selon Dalí,
le bourdonnement de l'abeille annonce un danger (piqûre) à la conscience profonde de la femme
endormie et déclenche un rêve. Dalí cite ici des motifs classiques du symbolisme freudien.

그림의 중심은 잠이 든 채 초현실적인 풍경 위를 떠다니는 갈라다. 달리의 말에 의하면,
윙윙거리는 벌은 잠든 여자의 깊은 무의식에 위험(독침)을 알림으로써 꿈을 촉발한다.
달리는 프로이트의 꿈의 상징에서 고전적인 이미지를 차용하여, 꿈의 내용을 조합했다.

この絵の中心は、眠ったまま超現実的な風景の中を漂うガラで、ダリによれば、
ブンブン飛び回るハチは休んでいる女の無意識下に危険(毒針)をもたらしている。夢の要素を
集積することによって、ダリはフロイトの夢の象徴性から古典的なイメージを導き出している。

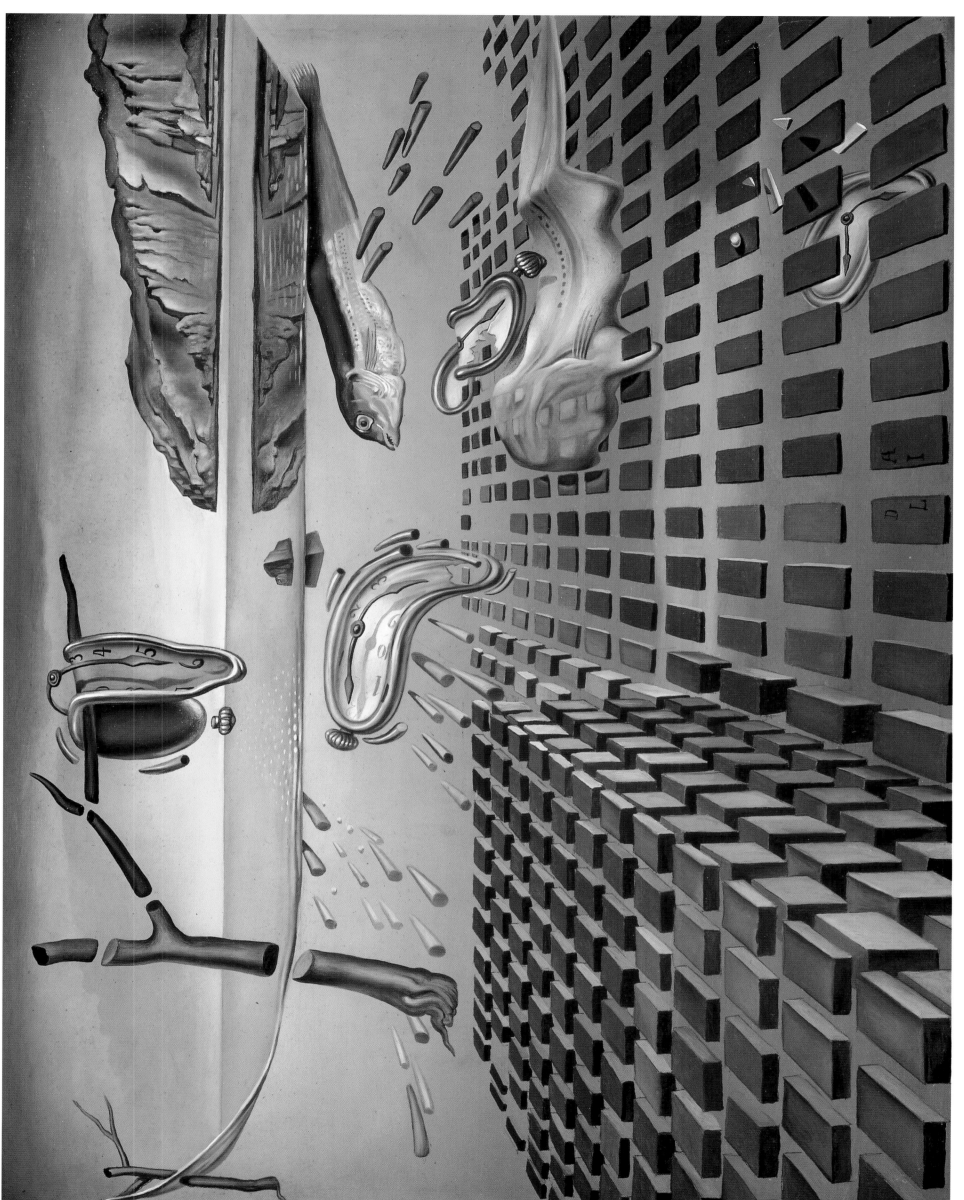

살바도르 달리 기억의 지속의 붕괴, 1952~1954년

Salvador Dalí
The Disintegration of the Persistence of Memory, 1952–1954
Auflösung der Beständigkeit
Désintégration de la persistance de la mémoire
기억의 지속의 붕괴
記憶の持続性の分解

Oil on canvas, 25 x 33 cm
St. Petersburg (FL), The Salvador Dalí Museum

Dalí's "soft watch" motifs belong to the most popular fabrications ever created
in pictorial art. The watches appear to be wilted leaves fallen from the stunted
tree-trunk on the left side of the picture.

Die „weichen Uhren" Dalís gehören zu den populärsten Bildfindungen,
die je von einem Künstler gemacht wurden. Es scheint, als seien die Uhren
wie welke Blätter von dem verkrüppelten Baumstamm am linken
Bildrand abgefallen.

Considérées isolement, les « Montres molles » de Dalí font certainement
partie des peintures les plus populaires qui soient. On dirait que les montres
sont tombées comme des feuilles mortes du tronc déformé, à gauche.

달리의 '늘어진 시계'는 지금까지의 회화 예술에서 가장 인기 있는
모티프 중 하나이다. 시계는 화면 왼쪽의 변형된 나무줄기에서 떨어지는
시든 나뭇잎처럼 보인다.

ダリの「柔らかい時計」のモチーフは、絵画の分野ではもっとも人気のある構図に属する。
時計は、左側の木の幹から落ちた萎れた葉のように見える。

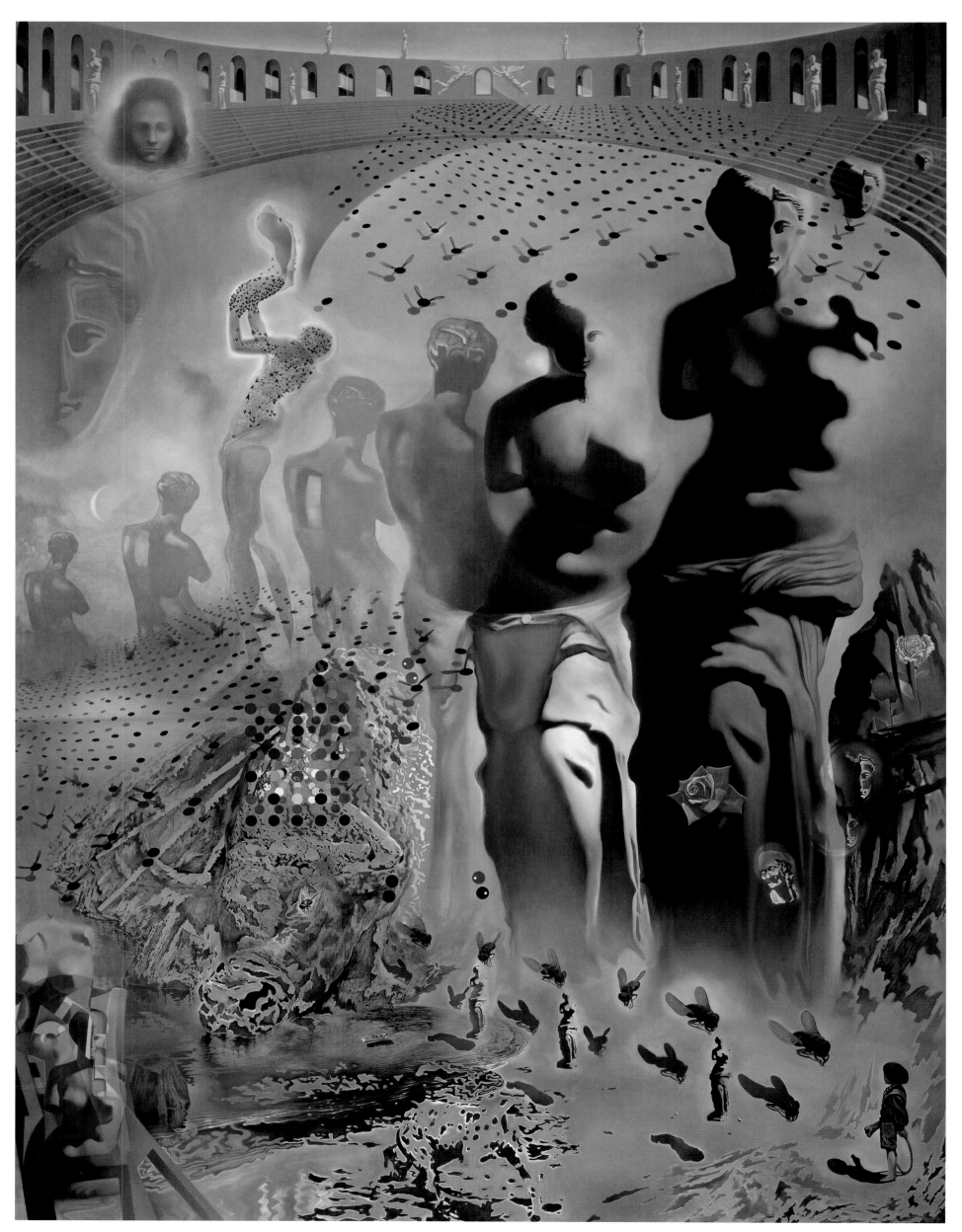

살바도르 달리 환각을 일으키는 투우사, 1968–1970년

Salvador Dalí
The Hallucinogenic Toreador, 1968–1970
Der halluzinogene Torero
Le torero hallucinogène
환각을 일으키는 투우사
幻覺劑的鬪牛士

Oil on canvas, 398.8 x 299.7 cm
St. Petersburg (FL), The Salvador Dalí Museum

A double image: the repeated figure of Venus de Milo and its shadow form the features
of a toreador. His luminous costume is derived from the multicoloured corpuscles and flies,
amidst which a bull impaled with spears can also be seen.

Dieses Doppelbild ist die Wiederholung der Venus von Milo mit ihren Schatten; sie zeichnet
die Umrisse eines Stierkämpfers, dessen Lichtgestalt aus der Vervielfältigung von vielfarbigen
Korpuskeln und Fliegen gebildet ist, die ihrerseits das Bild eines getöteten Stiers erzeugen.

Exemple d'image double: c'est la répétition de la Vénus de Milo, avec ses ombres, qui dessine
les traits d'un toréador dont l'habit de lumière est constitué par la multiplication des corpuscules
multicolores et des mouches, lesquels dessinent aussi un taureau foudroyé.

이중 이미지: 반복되는 밀로의 비너스 형상과 그림자가 투우사의 형태를 그린다.
그의 빛나는 의상은 다양한 색상의 미립자와 파리로 이루어져 있고,
그 가운데에는 창에 찔린 황소가 보인다.

2つのイメージ：ミロのヴィーナスの繰り返し続く姿とその影は鬪牛士の姿を形作る。その光り輝く
コスチュームはカラフルな球体とハエからできており、その中には球体が突き刺さった牛も見える。

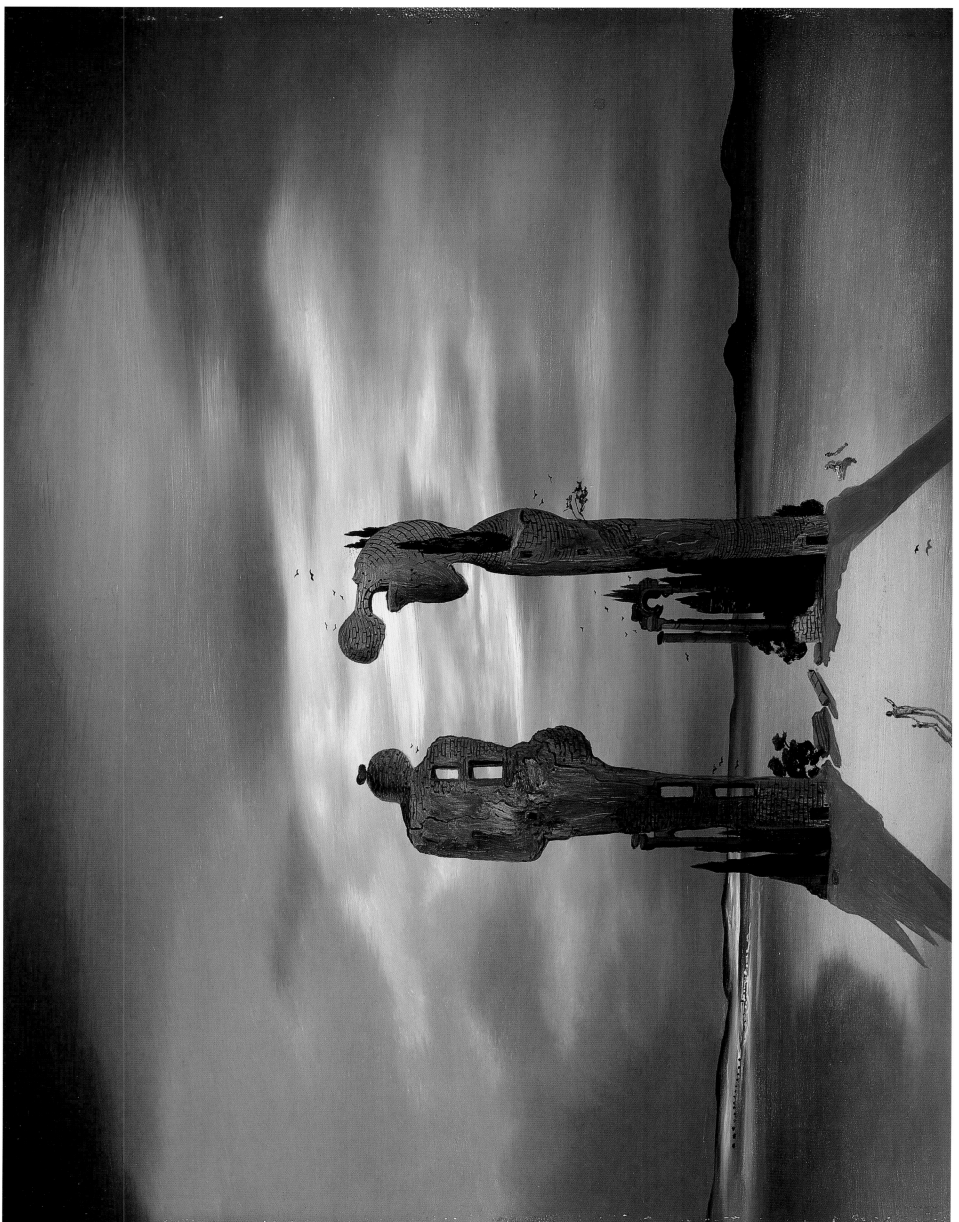

삶과 죽음, 그리고 〈만종〉에 관한 고고학적 회상, 1935년

Salvador Dalí
Archaeological Reminiscence of Millet's *Angelus*, 1935
Archäologische Reminiszenz des *Angelus* von Millet
Réminiscence archéologique de *L'Angélus* de Millet
밀레의 〈만종〉에 관한 고고학적 회상
ミレーの《晩鐘》の考古学的回想

Oil on panel, 32 x 39 cm
St. Petersburg (FL), The Salvador Dalí Museum

"In a brief fantasy I indulged in a walk to Cape Creus, whose stony landscape is true
a geological delirium, I imagined the two sculptured figures of Millet's *The Angelus* hewn
out of the highest cliffs."

„In einem kurzen Wachtraum, dem ich mich bei einem kleinen Ausflug zum Kap Creus hingab,
dessen Steinlandschaft ein wahres geologisches Delirium ist, stellte ich mir die beiden
Gestalten aus dem Angelusläuten von Millet als Skulpturen vor, die aus den höchsten Felsen
herausgehauen waren."

« Dans une brève fantaisie à laquelle je me livrai lors d'une excursion au cap Creus, dont le
paysage minéral constitue un véritable délire géologique, j'imaginai taillées dans les plus hauts
rochers les sculptures des deux personnages de *L'Angélus* de Millet. »

"크레우스 곶을 산책하면서 나는 짧은 환상에 빠졌다.
돌로 이루어진 그곳의 풍경은 진정한 지질학적 황홀경을 선사한다.
나는 밀레의 〈만종〉에 나오는 두 인물이 제일 높은 절벽에 새겨져 있는 것을 상상했다."

「クルース岬まで歩いている夢に耽けていた。そこは石景色で地質学上素晴らしい場所である。
ミレーの《晩鐘》の2体が、高所にある崖から削られて彫刻された姿を想像した」

SALVADOR DALÍ

© 2006 TASCHEN GmbH
Hohenzollernring 53, D–50672 Köln
www.taschen.com
Photo: The Salvador Dalí Museum, St. Petersburg (FL)

Korean Translation © 2006 Maroniebooks, Seoul
www.maroniebooks.com

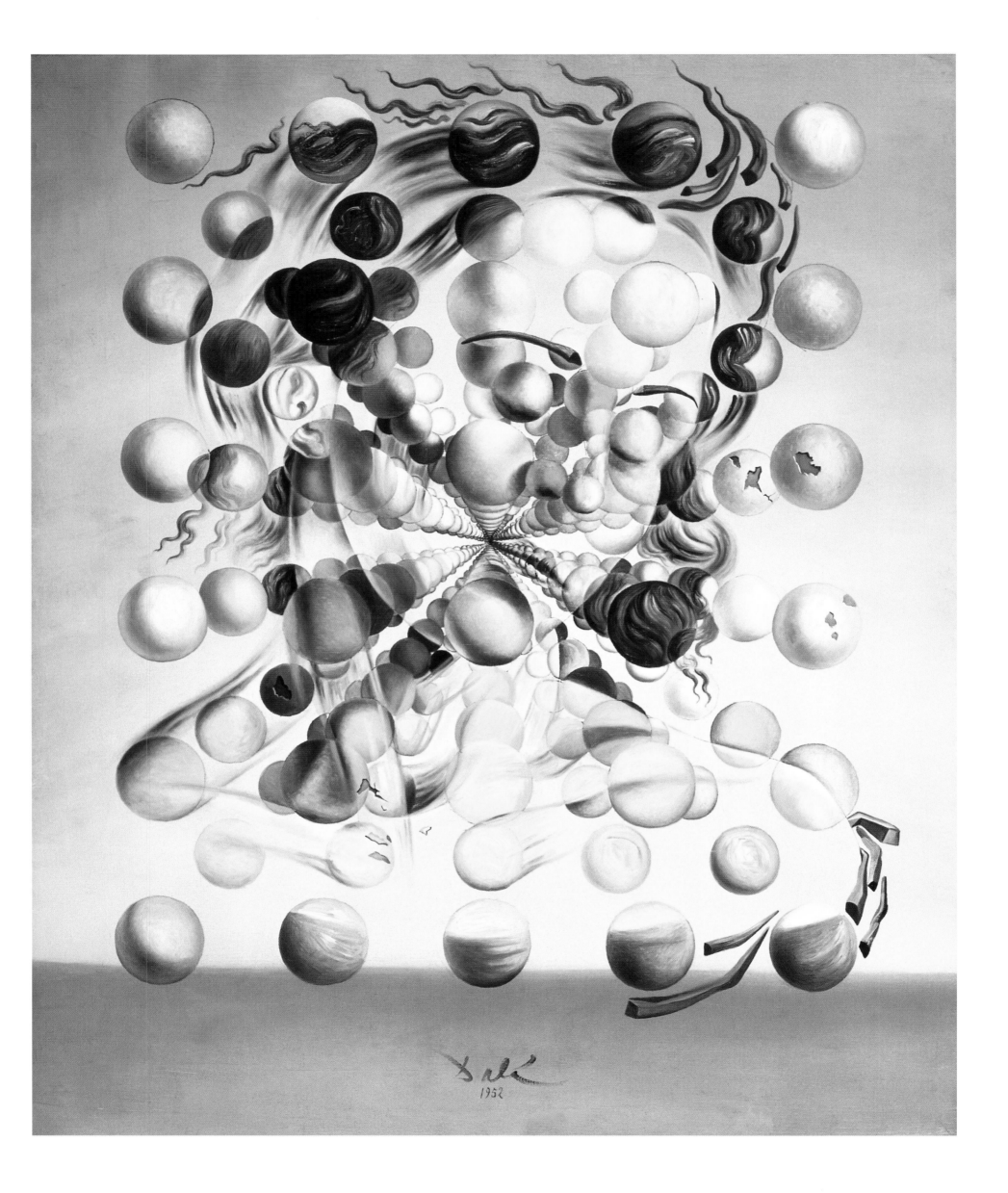

살바도르 달리 **천구의 갈라테아**, 1952년

Salvador Dalí
Galatea of the Spheres, 1952
Sphärische Galatea
Galatée aux sphères
천구의 갈라테아
球体のガラティア

Oil on canvas, 65 x 54 cm
Figueras, Fundación Gala-Salvador Dalí

To Dalí, this was the "paroxysm of joy", an "anarchic monarchy", "the unity of the universe ..." Whatever the case, it is a technical tour de force which reaches the pinnacle of purity and delirious ecstasy on the mystical plane.

Für Dalí ist dies der „Paroxysmus der Freude", eine „anarchische Monarchie", „die Einheit des Universums ..." Jedenfalls ist es ein unerhörter technischer Kraftakt, der auf der mystischen Ebene einen Gipfelpunkt der Reinheit und der rauschhaften Ekstase erreicht.

Pour Dalí c'est le « paroxysme de la joie », une « monarchie anarchique », « l'univers ... » C'est en tout cas un véritable tour de force technique qui atteint sur le plan mystique un sommet de pureté et de délirante extase.

달리에게 이 작품은 '기쁨의 격발'이자 '무정부 상태의 군주국'이며 '우주의 통일'이었다. 무엇이 되었건 간에, 이것은 신비스러운 평면 위에서 순수의 절정과 미칠 듯한 환희에 도달한 뛰어난 솜씨의 산물이다.

ダリにとって、この作品は「至上の喜び」「無政府主義の君主国」「宇宙の統一」・・・などを意味していた。たとえ何であろうと、技術上、大傑作であり、純粋さの頂点および神話的な面で恍惚状態に達している。

© 2006 TASCHEN GmbH
Hohenzollernring 53, D–50672 Köln
www.taschen.com
Photo: Fundación Gala-Salvador Dalí, Figueras

Korean Translation © 2006 Maroniebooks, Seoul
www.maroniebooks.com

살바도르 달리 《어린이-여자의 기억》, 1932년

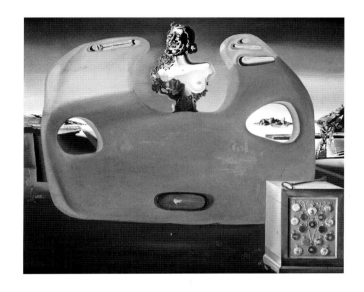

Salvador Dalí
Memory of the Child-Woman, 1932
Erinnerung der Kind-Frau
La mémoire de la femme-enfant
어린이–여자의 기억
子供・女の記憶

Oil on canvas, 99 x 119.5 cm
St. Petersburg (FL), The Salvador Dalí Museum

Nowhere did Dalí formulate his understanding of the meaning of life
more clearly than in this picture. The artist is indissoluably together with
his tool – the palette.

Deutlicher als in diesem Bild hat Dalí seinen Lebensinhalt nicht formuliert.
Der Künstler ist unauflöslich mit seinem Werkzeug, der Palette, verbunden.

Aucun tableau de Dalí n'a jamais formulé en termes plus clairs le sens de sa
vie. L'artiste est indissolublement lié à son outil pictural, la palette.

달리가 삶의 의미를 어떻게 이해하고 있는지를 이만큼 명확하게 보여주는
그림은 없다. 미술가는 결코 자신의 도구인 팔레트와 떨어질 수 없다.

この作品で、ダリは生命の意味をもっとも明確に表現した。
アーティストは自分の道具とかたい絆で結ばれている。それはパレットである。